To
Anna
love
from
Mummy
2005
X

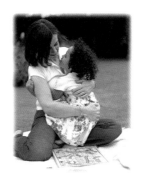

mothers & daughters

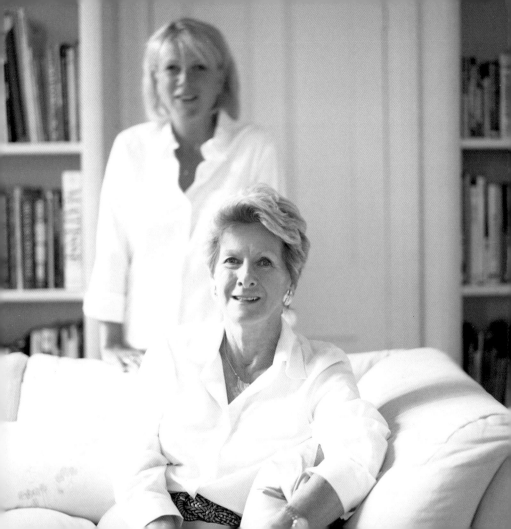

Sandra Deeble

with photography by Dan Duchars

mothers & daughters

RYLAND
PETERS
& SMALL
LONDON NEW YORK

For my mother, Joan Deeble.

Designer Emilie Ekström
Editor Miriam Hyslop
Picture & Location Research Emily Westlake
Production Deborah Wehner
Art Director Gabriella Le Grazie
Publishing Director Alison Starling

First published in the United States
in 2003 by Ryland Peters & Small
519 Broadway
5th Floor
New York NY 10012
www.rylandpeters.com

10 9 8 7 6 5 4 3

ISBN 1 84172 410 6

Printed and bound in China

it's a girl!

A daughter

You've been saying all along that you would be happy with either a boy or a girl. "I really don't mind," pregnant women insist, "as long as the baby is healthy." Yet, when you give birth to a daughter, does it strike a particularly intimate resonance? If you have a girl, do you immediately celebrate

the fact that you have created a lifelong companion, a soulmate? For a mother, is a daughter a dream come true? Some mothers admit that during their pregnancy they convinced themselves that they were going to have a boy just so that they wouldn't be disappointed if they did. Others say

that they found themselves being drawn to all things feminine as they allowed themselves to wallow in the possibility of having a baby girl. "I always thought that, if I'd had a girl, it's not that everything would have been pink and frilly with lots of Barbies, but it might have

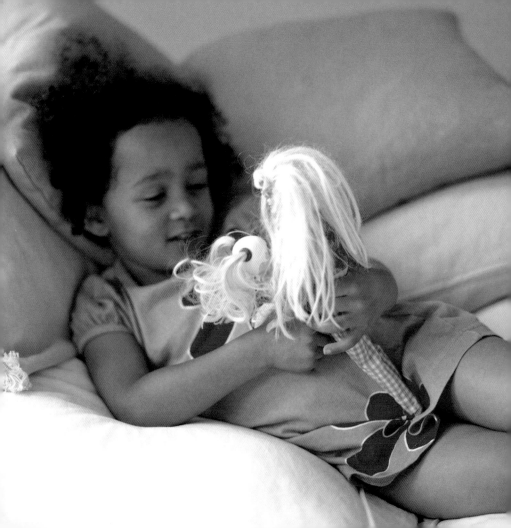

given me the opportunity to celebrate the girly side of me," says the mother of three boys. The same mother admits that when she sees her teenage son huddled with his friends in front of a computer, all of them wearing hoodies, she says: "It's beyond me. I don't understand boys. I just don't comprehend the things they do." Many women say that having a daughter is blissful because girls are more fun. You can have the cozy chats, play with tea sets, and indulge in hours of pleasure with make-believe games of hairdressers and shopping. In the early years, your house becomes a sea of pink. One mother says she has to do a separate pink wash for her two little girls and confesses that she has even started wearing the odd pink sweater herself. For a while at least, pink is the new black. One day, having survived the teenage years, you'll become good friends. Your ultra-cool, grown-up

daughter will realize that a girl's most reliable accessory is her mom. Spending time together will become a delight as you indulge in some serious shopping trips, go out for dinner, have a giggle, and celebrate the fact that you're girls together.

It was totally overwhelming when my daughter was born. I had a great rush of affection. I was completely in awe of her.

Diana Marsh

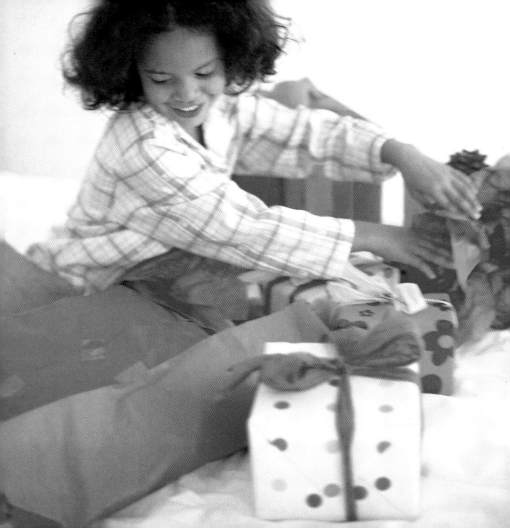

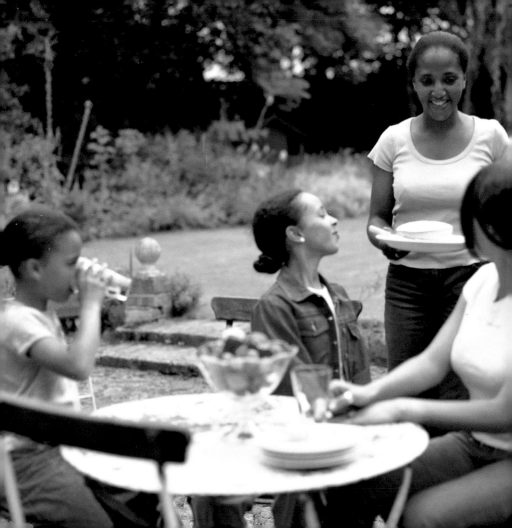

If your child eats what you've lovingly prepared for her, you're in heaven. She's full of goodness! When she rejects it, you try not to take it personally, but it's difficult. And when she goes to a friend's house and eats chicken nuggets and oven fries, you can't wait to get her home to purify her system with some steamed vegetables and fresh fruit.

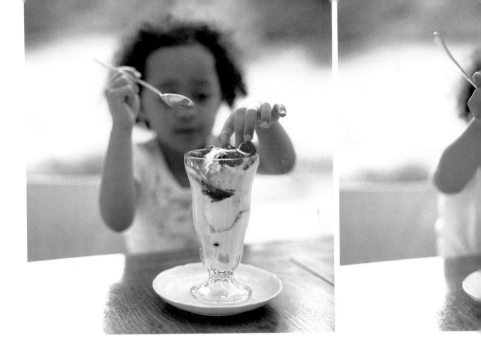

More often than not, however, she'd rather fill herself up on sundaes and sweets! And it doesn't get any easier when your daughter becomes a teenager. It's far better if you don't know she's using her lunch money to buy cigarettes.

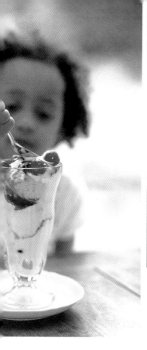
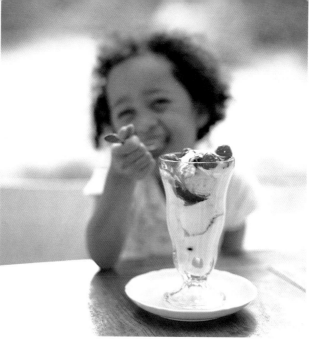

She longs to look like a supermodel. When she does eat, she wants fries. But weren't you the same at that age? Okay, so it might have been nothing more harmful than a milkshake at McDonald's, but it was still considered an act of rebellion.

As we grow up, many of us remember the particularly comforting things our moms used to cook for us. Before we know it, we're calling her to get the recipe. Food is a love gift! Young children understand this, even though their gifts may amount to no more than a few burnt offerings or some rather iffy bread brought home from a cooking class at school. Hasn't breakfast in bed for moms on Mother's Day become a time-honored ritual in many families? And when you've left home, and have your own place, it's lovely to be able to cook for your mom once in a while—especially when you think of all the meals she's cooked for you! Above all, food provides opportunities for intimacy and sharing. Cooking something special for your mom—something you've learned to do yourself, and perhaps something she wouldn't normally eat— is a way of telling her a bit more about who you are.

flying the nest

Freedom can be scary

It's your daughter's first day at kindergarten. How can you possibly leave her? Will she make friends? Supposing she's left feeling lost, wondering what's going on? And what if she

cries, and wants you, and you're not there? The morning is agony for you. You've longed for some time to yourself, but now all you can do is worry about her. You're there to pick her up far too early, longing to be with her again. Years later, your mother drives you to college. She gives you a hug after settling you into your new room. This time, you're the one reassuring her. I'll be fine, you say, I'm a big girl—this will be a cinch! Yet when she drives off—the car much lighter now that it's shed its load of PC, potted plants, CDs, books, and clothes— you wish you were three years old, and that your

mother could come to pick you up to take you home for lunch. For this next new phase of life, you're on your own. You're free, but freedom can be scary. When is Thanksgiving? Perhaps you could go home for that. Then, one day, the roles will be reversed. Your mom may find herself alone for the

very first time in her life. She's going on vacation by herself: an activity break with massage and t'ai chi classes! You can't believe it. You tell all your friends, and they think she's cool, saying: "I wish my mom would do something like that." You offer to take her to the airport. This time, you're the one who'll do the worrying. Will she meet like-minded people?

Supposing she has a fling? She'd better be careful! For once, you know how she's felt on countless occasions throughout your life. When she comes home, she looks ten years younger, full of energy, with dozens of stories to tell you. She's had such a good time that you say: "Next time, shall we go away together?"

Your children are not your children.
They are the sons and daughters of
Life's longing for itself.
They came through you but not from you.
You may give them your love
but not your thoughts.

Kahlil Gibran

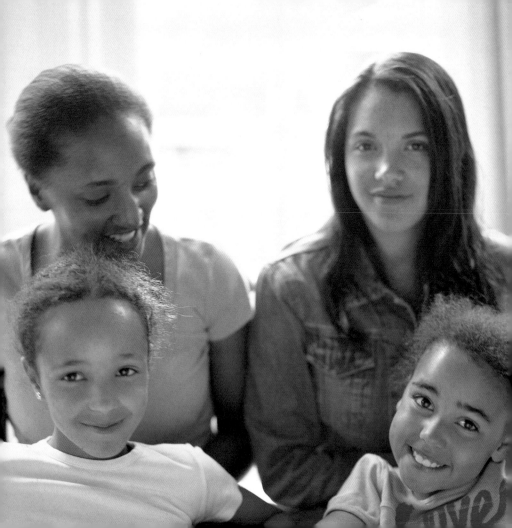

*you're just
like your mother*

Do we all grow into our mothers?

As a daughter, do you spend your life trying not to be like your mother? When someone says: "You're just like your mom," do you smile sweetly and take it as a compliment? Or are you more likely to wince? However much you may resist emulating your mother, it's a tough one. You might find yourself doing something as banal as wiping a kitchen surface, when all of a sudden you feel as if you're watching your own mother doing it. Is it inevitable? Do we all grow into our mothers? When you're growing up, you vow that you'll never ever embarrass your daughter in front of her friends. You wear sweat pants and trainers to meet her at the school gate. But she finds it excruciating. "You're trying too hard," she says with disdain. You attempt to keep up with the latest music. You drop a

All women become like their mothers.
That is their tragedy.
No man does. That's his.

Oscar Wilde

band's name. "Act your age," your daughter tells you. You want to talk to her about petting, but before you get around to it, she's way ahead, talking to her friends in graphic terms about pecs and sex. As daughters, we don't want to re-enact our mothers' lives in any way. We have so many more choices than our mothers ever had; we know we're lucky, but at the same time we're overwhelmed. There are far too many decisions to be made! For mothers and daughters, it's all too easy to compare and contrast lives. However different each generation's lot seems to be, there will always be similarities. And while you might believe that you and your mom have very little in common—having spent years trying to be your own person—there will always be days when you think to yourself: "I can't believe I've just said that. I sound just like my mum." Or a girlfriend may tell you a story about her

experiences that sounds all too familiar. "The other day we were watching a boy band on television and I caught myself saying: 'There's no real melody, is there?' I could have cut out my tongue! I used to hate the way my mum would ruin the chart shows by saying things like: 'She can't really sing, can she?'" Whatever you do to attempt to keep up with your

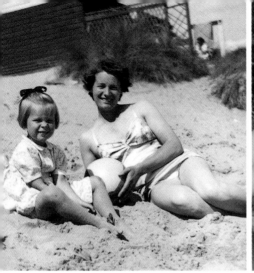
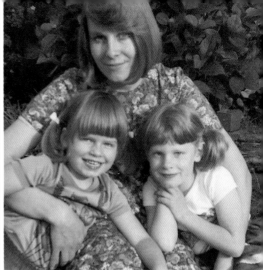

daughter, it's bound to be a lose-lose situation. You just have to bide your time. One daughter now in her late thirties says that her mom has become one of her best friends, and she really wants her own friends to know how special her mother is. Inviting her mom along to her hen weekend was one way of doing this. "As we get older, I can feel our roles

reversing," she says, "and I am now becoming her teacher and protector. What is so great about her is that she is always ready to try something new, and will go anywhere with me." As a new mother, you might find yourself looking at your little girl and thinking: "Was I ever like her?" Perhaps your own mother will be a witness to her early years. How will it make you feel, when your mom looks at her granddaughter having a screaming tantrum, and turns to you with a knowing look, and says: "I wonder where she gets it from?" Or maybe you'll look at your mom and think to yourself: "I wonder what I'll be like when I'm her age?"

As is the mother
So is her daughter.

Ezekiel

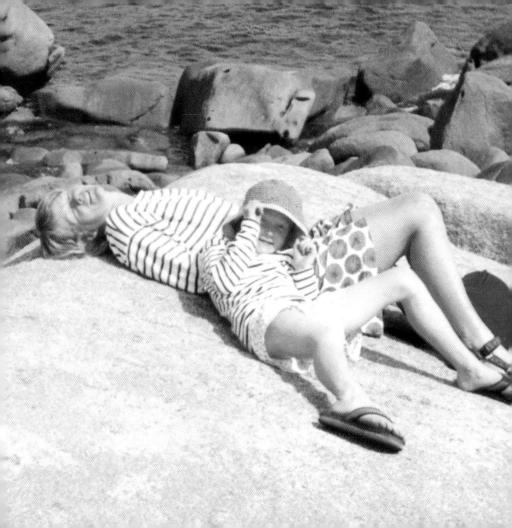

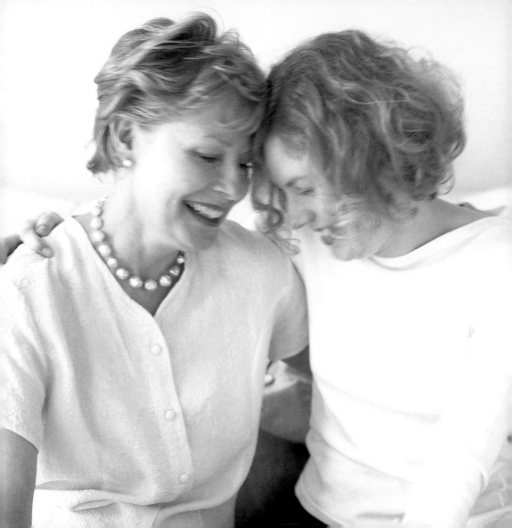

just the two of us

"My daughter's a soulmate."

"I can sit in cafes with her and chew things over. I'm not really into shopping, though. But I can definitely do toenail painting, yoga, and spas!" Do you remember the first time you had really good fun being out with no one else but your mom? Was it going shopping? What about going to buy new shoes? Perhaps you still remember the smell of waxy leather and the thrill of unscuffed, shiny toes. You were always asked if you wanted to wear them immediately and whether you wanted the box to take home, perhaps to keep special things in? One woman who grew up with lots of brothers and sisters

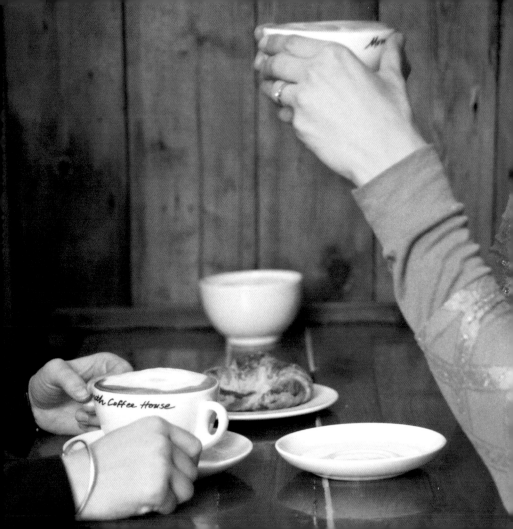

said that the only occasion she spent time alone with her mom was when they went to buy new shoes for her. It became a treat that she much looked forward to. Years later, she is addicted to shoe shopping.

She admits that she now attempts to recreate with Manolos and Jimmy Choos sacred rituals that began with Oxfords. She regrets that she has developed such an expensive way of reliving those memories of her mother! "Quality time" has become a tired cliché, yet long before it became quotidian, mothers and daughters were enjoying time together, perhaps to get away from the rest of the family, or just for the joy of hanging out together. And being able

to take your mother out—and pay for her—is a true rite of passage. One "thirty-something" daughter treated herself and her mother to a vacation in Menorca—just the two of them. It was the first time they had been away without the men in their family. Her daughter says that being in a restaurant and witnessing all of the waiters flirting with her

We shop very well together.
That's a big thing for bonding.

Rachel Boothroyd

mother made the price of the trip worth every single dime! Closer to home, spas and other pampering treats are winners when it comes to daughters treating their mothers to some time out. If you can find something that you enjoy doing together, you'll both be in your element.

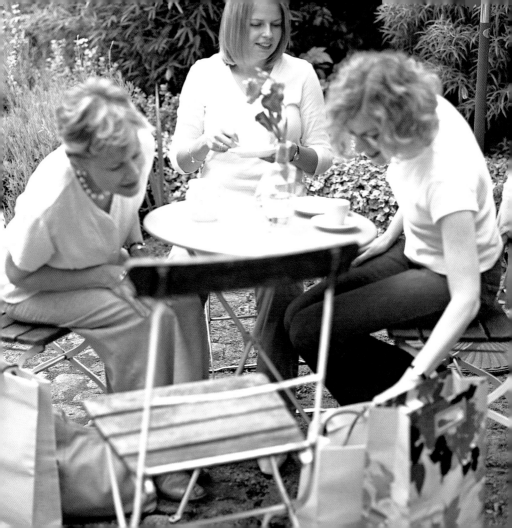

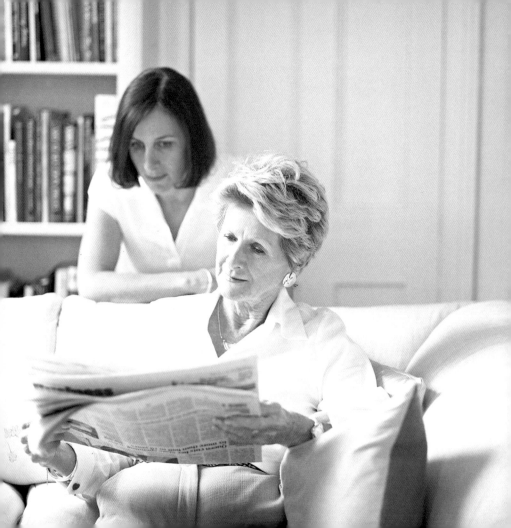

too close for comfort

Bittersweet love

It's not all roses. Or hugs, kisses, and handmade posies. The love between mothers and daughters is interwoven with profoundly complex issues. What is it that makes this love bittersweet? As a daughter, do you see your mother in certain situations and feel that you're looking at a mirror image of yourself when you're older? As a mother, does it hurt you to see your teenage daughter dressed up to go out, and looking stunning, when you realize that you're never going to look like that again? You feel guilty. And if you're not feeling guilty about jealousy, you're bound to feel guilty about something else. As the mother of a three-year-old girl puts it: "Whatever you do, you always feel guilty. If you go to work, you feel guilty. If you stay at home, you feel guilty that you're letting

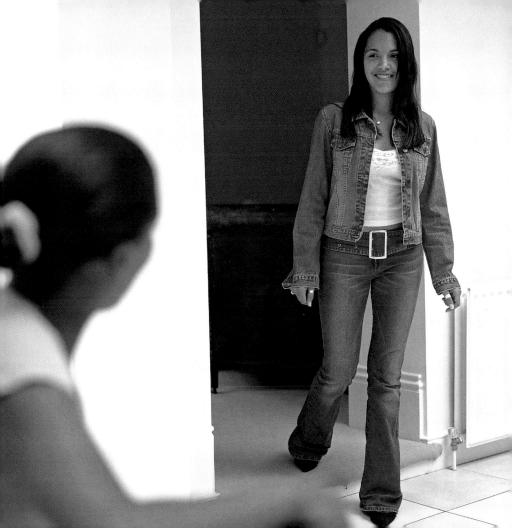

So for the mother's sake the child was dear,
And dearer was the mother for the child.

Samuel Taylor Coleridge

her watch television instead of doing creative activities. As a mother, you're always guilty!" And daughters can feel guilty, too. Things have been manic at work, and you haven't called your mom for ages. When you go home to visit your parents with your boyfriend, you never spend enough time with her on her own. Or she's left messages for you on your voicemail, but you've hardly been at home all week, and by now you know she's wondering if everything is okay. The empathy that binds mothers and daughters comes at a price. The closer you are, the more likely you are to clash. And even if there is rarely conflict, you are likely to feel each other's disappointment and pain viscerally. Yet, when something good happens for mother or daughter, the news is all the more likely to be celebrated with mutual joy, fueled by a deep-rooted love. One recently married woman in her late thirties

says that her mother has been there for her at every new beginning and every milestone in her life. Her first day at school, concerts and plays, 16th and 21st birthday parties, graduation, getting dressed for her wedding, and waving her off on her honeymoon. Some daughters admit to feeling guilty about the selfless love demonstrated by their mothers. They are always happy to share their daughters' joy and achievements, and don't seem to mind their supportive role. No wonder, then, that it feels fantastic when your mom tries new things for the first time. With a bit of encouragement from you, your mother can embark on all kinds of new adventures and experiences. Two sisters, for example, clubbed together to buy their mom a year's membership of a dating agency for her birthday! It wasn't exactly the most successful present, but it's the thought that counts—isn't it?

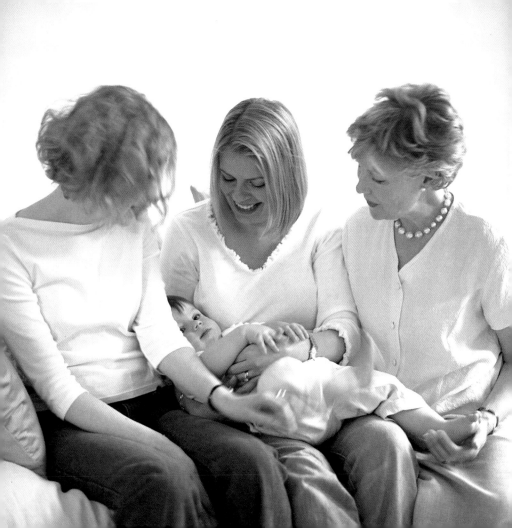

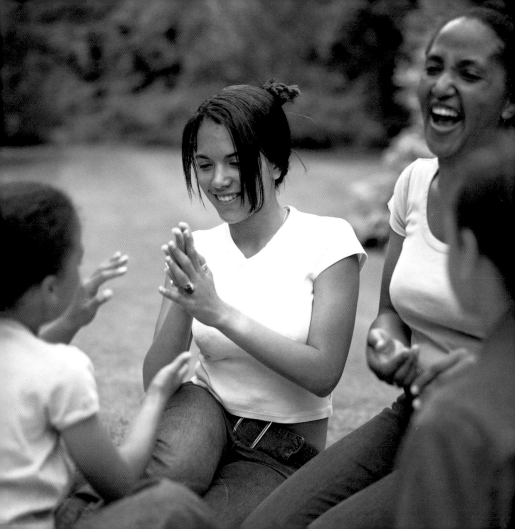

celebration!

Celebrating motherhood across the generations is something to cherish

When you become a mother for the first time, do you suddenly start to feel less like a daughter and more like a mom? "I think I will always feel more like a daughter," says one relatively new mum, who still regards her mother as the person who deserves to be fêted on Mother's Day, rather than expecting her young daughter to pamper her. As a mom, when you look back at all the things you learned from your own mother, which of them will you pass on to your daughter? Which of them will you reject? Will you do anything, or everything, differently? Or are you suddenly likely to view your childhood through fresh, more benevolent eyes? There's nothing like seeing yourself as the mother of your newborn

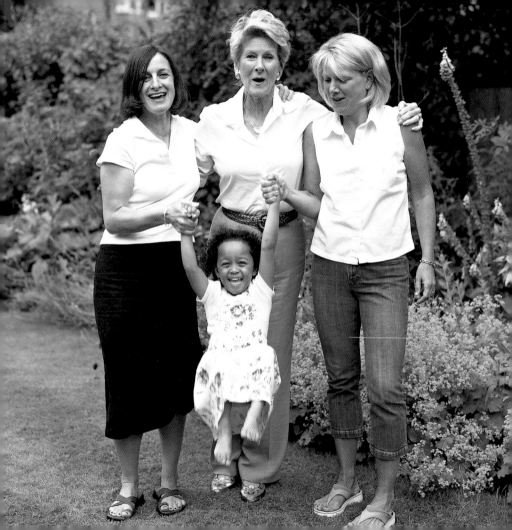

daughter to make you re-evaluate the relationship you have with your own mom. If you've always had a good relationship, the birth of your daughter will only strengthen your love. Yet

Now that I'm a mother myself,
I see a lot of my mom in me.

Alice Wheeler

there are many women who say that, after giving birth to their baby girl, they found a way of bonding with their mothers, having spent years attempting to forget the word "daughter" in order to become their own person. Mother's Day evolves to embrace the new girl in the family. Take one newborn daughter—who doubles as a granddaughter—one proud new mother, and a grandmother who is pleased as punch, and you

have quite a formidable line-up. Enjoying celebrations
together with your mother and your own daughter will create
lovely memories for your little girl, and will mean that you and

your mom are able to relive some of your own. You might find yourself making a birthday cake for your daughter and suddenly have a flashback to a time when you watched your own mom icing a cake before your party. Your mom will hear your daughter singing along to the radio, and remind you that you always loved to sing. You might not want to be reminded of these facts, but one thing about becoming a mother yourself is that you suddenly begin to appreciate all the things your mom used to do for you.

We always celebrate Mother's Day, birthdays, and whatever else we can think of. I think you should take the opportunity to celebrate whenever you can!

Diana Marsh

picture credits & acknowledgments

The publisher would like to thank all those that kindly
leant photographs from their family albums and the models;
Ann, Melissa, and Mandy De Leon with Eve De Leon Allen.
Karen Dean and Jasmin, Chantal, and Olivia Kindlen-Dean.
Liz and Emily Westlake and Sarah and Max Khan.

Key: **a**=above, **b**=below, **r**=right, **l**=left, **c**=center, **ph**=photographer
All photography by Dan Duchars taken at Francesca Mills' house in London
(unless stated otherwise)
8–9 ph Debi Treloar; **12 a ph** Polly Wreford; **12 c ph** David Brittain;
12 b ph Christopher Drake; **13 ph** Polly Wreford; **17 r ph** Debi Treloar;
21 ph Debi Treloar; **24 both ph** Debi Treloar; **25 ph** Andrew Wood;
26 ph Chris Everard/Gentucca Bini's apartment in Milan; **27 ph** Andrew Wood;
42 ph Debi Treloar; **43 ph** Chris Everard; **44 ph** Debi Treloar; **45 ph** Chris Everard;
59 ph David Brittain/an apartment in London designed by Elizabeth Blank,
Floral and Interior Designer t.+44 (0)20 7722 1066; **62 ph** Polly Wreford.

The author would like to thank all the mothers and daughters who contributed to this book.

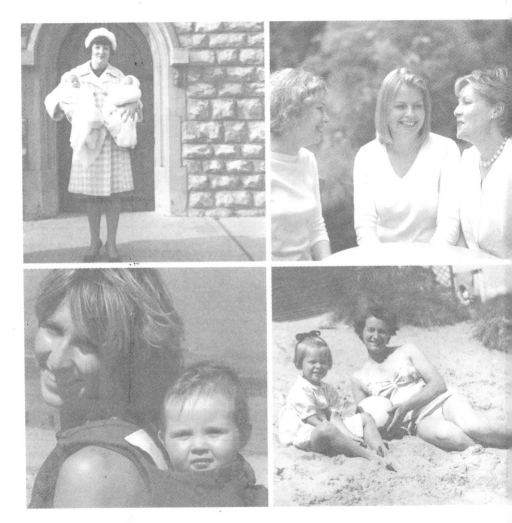